Dim Sum 點心

a surviva...

LIZA CHU

BLACKSMITH BOOKS

To Alex and Jasmine

Dim Sum: a survival guide

ISBN 978-988-17742-3-1

Published by Blacksmith Books
Unit 26, 19/F, Block B, Wah Lok Industrial Centre,
37-41 Shan Mei Street, Fo Tan, Hong Kong
Tel: (+852) 2877 7899
www.blacksmithbooks.com

Copyright © 2010 Liza Chu
Fourth printing 2018

All rights reserved. No part of this publication may be reproduced, stored in a retrieval system,
or transmitted in any form or by any means, electronic, mechanical, photocopying, recording or
otherwise, without the prior written permission of the publisher. While every effort has been made to
ensure the accuracy of the information contained in this book, neither the author nor the publisher
can take responsibility for any loss or injury arising from its use.

Food photography by Trio Photo

Page layout by Alex Ng Kin Man Illustrations by Mariko Jesse

Dim sum dishes graciously provided by
Golden Bauhinia Cantonese Restaurant, Hong Kong
Super Star Seafood Restaurant, Hong Kong

Contents

How to use this guide

*J*am a teacher of Cantonese language and local culture to expats, and we always finish a semester with a trip to a dim sum restaurant for lunch. Now lunching with twelve people of different nationalities, each with their own dietary customs, is pretty chaotic as you can imagine. Add the fact that the wait staff speak limited English and what we have is confusion and miscues.

This book is designed for the dim sum devotee who would like to fully enjoy the experience without compromising on dietary restrictions. Whether you or your friends are vegetarian, kosher, allergic to peanuts or prawns or just plain old conservative, this guide can help you navigate your meal. New dim sum dishes are being invented daily but I have tried to include the traditional mainstays of Chinese restaurants. You may see new dishes that are a variation on the theme but don't be surprised if what you are served is not exactly the same as in this book.

Dim sum restaurants now operate in either of two ways. The traditional, more fun, way to be served dim sum is where nice middle-aged ladies push steaming hot carts around the restaurant floor. Chinese placards on the front of the cart

display the names of dishes inside the bamboo steamers and the ladies shout out their delicious offerings. Flag down the cart and order your food. Everything is hot and ready to go. The disadvantage of this system for the restaurant is that there are always plenty of leftovers as they cannot possibly sell every last dish that they make in advance.

So a new type of ordering system has emerged, especially in smaller establishments. Dishes are cooked to order. You sit down with an ordering card which has a list of dishes that are their specialities. You need to mark the quantity of baskets you would like for the dishes you want to try. Orders are then placed and your food will be cooked and brought to you. Once it arrives, your wait staff will chop your payment card for the value of the dish.

The main part of this book contains pictures of each dish, and observations from my friends to give you an idea of what it tastes like. Icons on each page help you decide whether the dish is suitable for you. Once you are familiar with the items, you can use the flip-out chart and point to order what you like. The last section of the book lists some handy Cantonese phrases for you to try out with your wait staff.

Dai ga sik fan – everyone, let's eat!

Safe for people with peanut
allergies

This dish does not contain pork

This dish does not contain meat
or seafood, but may contain eggs

This dish does not contain eggs

This dish does not contain
shellfish

This dish does not contain any
meat, but may contain seafood

The History of Dim Sum

There are several theories on where and when the art of dim sum originates. Search through some ancient Chinese texts and you will read that dim sum dates as far back as the Eastern Jin Dynasty (317–420 A.D.)

Some argue that it is a Northern Chinese invention and some are adamant that it originated in the South, though it has been documented that the North has a longer history of dim sum, starting in the Tang Dynasty (618–907). These dishes made their first appearance in the South in the time of the Ming (1368–1644). It seems that in the North, dim sum was originally served only to the upper classes and magistrates, whereas in the South it was the commoners' food. It seems that culinary trends start with the elite and filter down to the masses.

Here are some stories about dim sum through the ages.

There was a great general during the Eastern Jin Dynasty who commanded his soldiers to fight night and day, beating their enemies and winning battles. In gratitude to his troops he ordered his kitchens to make delicious and famous local

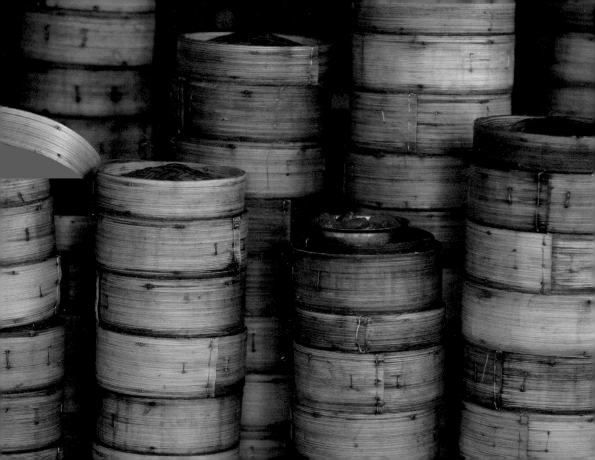

dishes, and delivered them to his soldiers on the front line (a little bit of 'heart-felt thanks'). Since then, 'dim sum' or 'a little bit of heart' has been used to describe these dishes.

During the Leung Dynasty (420–589) Prince Chiu Ming states that dim sum was a snack.

In the Tang Dynasty the wife of Magistrate Cheung, who lived south of the Yangtze River, was sleeping in. The wife said to her brother, "I have not finished my morning grooming. I can't make it to breakfast. Why not ask the servants to make me a little something to eat now?" So snacks in the morning were known as 'dim sum'. Another Tang Dynasty writer, Chou Fai, wrote: "After you wash your face and get ready in the morning, the dim sum will arrive". He then states that dim sum consisted of steamed plain buns, won tons, dumplings and so on, so we know that this phrase was already in use during Tang times.

In the Qing Dynasty (1644–1911) the term 'dim sum' was described as small snacks by Gu Cheung Xi, the author of a guidebook.

So the term 'dim sum' has been used for centuries for the idea of a morning snack. It has since evolved to mean small dishes served for breakfast and lunch.

Table Manners

Cleaning dishes

*I*n Chinese restaurants you may see a frequent occurrence: Chinese people washing their dishes at the table. Why do they do this? Well, they believe that if they rinse the chopsticks, tea cups and bowls in the hot, almost-boiling water or tea, then this will disinfect the utensils. Not all restaurants have industrial-size dishwashers so maybe dishes are hand-washed in a tub of water. Also, waiters and waitresses may inadvertently wipe their hands on clean utensils so it's a good idea to give everything a good rinse. Please note that Chinese people don't eat from their plates. Plates are mainly used for holding bones or discarded pieces of food, so plates are left unwashed.

This practice is not appropriate in first-class hotels and restaurants, so please don't try! If in doubt, look over at your Chinese neighbours and see what they are doing.

Chopsticks

Dishes are usually placed at the centre of the table for everyone to share. Your wait staff might leave you extra pairs of 'communal' chopsticks for picking up food from the shared dishes. These may be the same or a different colour from your individual chopsticks. This is to prevent chopsticks that have been in other diners' mouths coming into contact with communal food. If you have trouble manoeuvring the morsels to your bowl, you can bring your bowl closer to the plate. If you are still having trouble, it is perfectly acceptable to use your chopsticks to scoop your food onto your spoon, then lift it into your bowl.

If you are eating with Chinese people, try to choose the morsel closest to you. Also, try to take the first piece you touch, rather than picking up and putting down several pieces before you settle on the choicest one.

It's considered impolite to point chopsticks at someone or to stick chopsticks vertically into rice like incense sticks. If you need to put your chopsticks down, try to lay them on the little rests or on your 'bones plate'.

Eating from your bowl

You may feel uncomfortable at first but over a billion people do this! Lift your rice bowl to your mouth, rest it on your bottom lip, then using the chopsticks, scoop rice into your mouth.

You can use your chopsticks to pick up noodles. It's OK to slurp. You may drink the soup with your spoon. It is not uncommon to see men bring their bowl up to their lips to drink from it.

Bones or discarded pieces of food can be left on the plate.

Fighting over payment

There's a scuffle at the next table. Chinese people are yelling and pulling at each other. The waiter is caught in the middle looking confused, scared and embarrassed. It sounds like a serious argument and you are expecting punches to be thrown at any minute. What you are witnessing is a polite face-giving fight over who pays for the meal.

Chinese people don't split bills. One person pays for the whole table and then it's the other person's turn the next time around. But in order to give face to

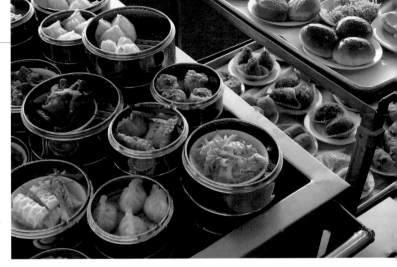

everyone, you will see a table of adults fighting to whip the bill from the waiter's hand or try to throw cash or a credit card to him in order to show generosity. They will argue whose turn it is to pay and a multitude of reasons why it's their turn to treat. All this is done in fun and good humour but, to the uninitiated, you'd think the altercation was serious.

My mother and I have practised this dance for years and it's gotten to the point where she will pretend she's going to the bathroom to powder her nose and then make a detour to the cash register to pay for the lunch. Sneaky!

The etiquette of tea drinking

Y um cha in Cantonese literally means 'drink tea'. However, the phrase has come to represent the entire experience of dining on dim sum, because tea is such an important part of it.

Drinking/pouring

In restaurants it's not uncommon to get two pots of tea, in addition to a pot of hot water to continuously fill it up so the tea doesn't sit too long and get cold. If you would like your waiter to refill your pot of tea or water, then balance the lid of the teapot over the top and the handle. This is the universal sign language for Chinese waiters worldwide to top up the pot with boiling hot water. If you want to cool your tea, then I would not suggest balancing your teapot lid in this way as your waiter may pour hot water into a pot that is already cooled or, worse still, spill the boiling contents onto your lap as they think they are removing an empty teapot. The remedy is to either bring a bottle of cold water or just be patient and let the tea cool of its own accord while you enjoy the dim sum.

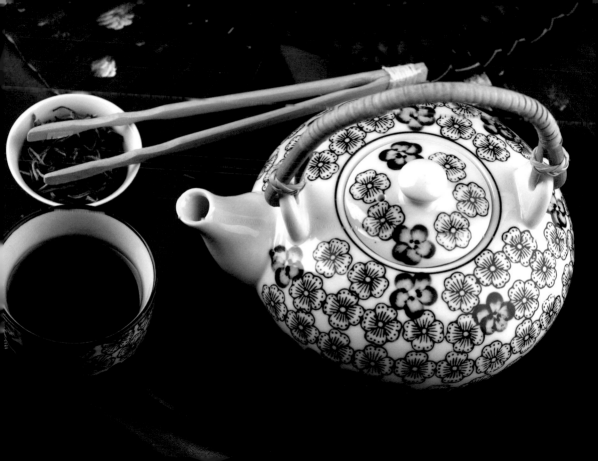

You will often observe Chinese people tapping the table as a sign of thanks to whoever is pouring. This habit is said to originate from the Chinese Emperor Qianlong, who went out incognito into the streets and tea houses of Beijing, and poured tea for his subordinates. Unable to show their gratitude to the Son of Heaven without blowing his cover, the courtiers tapped the table as a symbol of kneeling and kowtowing to him. Pouring tea is a sign of respect for others, so tea is always poured for other people before serving yourself.

You'll often see several different pots of tea on the table. Restaurants usually put a small tea charge, calculated per adult, on your bill. So why not order the tea that you like? Everyone may order their own favourite brew, hence several different pots at once.

Origins of 'tea'

Did you know that in all the different languages of the world, 'tea' is only known by two names? In most of China (including Hong Kong) the word is pronounced as 'Cha'. However, in the Min dialects of Southeast China (Hokkien/Fujian Province) and Taiwan, the drink is pronounced as 'Teh'. The written Chinese character, however, is the same in both cases.

Hence, depending on which part of China the tea trade originated from, foreign words for these leaves would be either 'Tea/Te' (e.g. in English, French, German and Malay), or 'Cha' (e.g. in Greek, Turkish and most East Asian languages).

Interestingly, whilst the British developed the tea industry in India, languages in southern India and Sri Lanka share the British pronunciation of 'Tea/Te', but languages in northern India and now Pakistan call the drink 'Chai'.

Moreover, between Spanish and Portuguese, which share the same linguistic origins but had different trade links, the former adopted the 'Te' pronunciation, and the latter, the 'Cha' pronunciation.

Health benefits

According to second-generation tea expert Henry Yeung, green (also known as white) tea has strong antioxidants, such as flavonoids, which are beneficial to health. Drinking black (or red) tea, which has gone through a fermentation process, does not provide as many antioxidants but is still beneficial. According to Yeung, the Yunnan region of China produces the highest quality tea. Good tea,

like good wine, can be aged. It is not unusual to see 20-year-old teas in quality tea shops. In fact, the older the tea, the lower the caffeine levels.

Before 1949, Chinese tea production was of a high hand-made quality. Tea leaves were gently hand-pressed with stone. But from the 1950s, tea production was centralized in state-run collective factories, so leaves were processed by machine and were more than likely over-handled and crushed. Teas at that time were graded by the length of their leaves as opposed to the quality of flavour. Now, this industry has again been reformed, and smaller farmers can once again harvest with care.

Types of tea

JASMINE GREEN TEA – 茉莉香片 – *Heung peen*

The lightest green tea, very popular with tea novices and Westerners. Flavoured with jasmine flowers. Very fragrant.

Strength: 1 out of 5

PEONY WHITE TEA – 牡丹 – *Mao dan*

A light tea with a light colour, sweet in taste.

Strength: 2 out of 5

SHUI SIN – 水仙 – *Shui sin*

A light type of oolong tea with a sweet aftertaste. Smooth texture.

Strength: 4 out of 5

IRON BUDDHA – 鐵觀音 – *Tit goon yum*

A strong tea, often drunk from small thimbles. Strong flavour, dark colour.

Strength: 5 out of 5

PU-ERH – 普洱 – *Bo lay*

The most popular tea among Chinese. Prices can range from a few dollars to thousands of dollars. Don't worry, your dim sum restaurant won't charge you that much. Strong fragrance and flavour; the tea becomes darker and stronger as it's brewed again and again during your meal. A strong aftertaste as well. Good for digestion.

Strength: 5 out of 5

Steamed

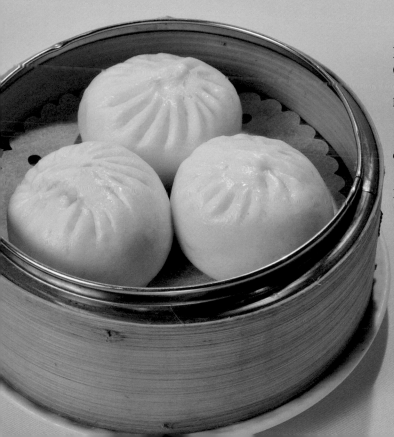

BBQ PORK BUN – CHAR SIU BAU – 叉燒包

Brian: I have never seen these before. They taste like Chinese hamburgers.

Carl: The fluffy bun is kind of sweet.

Liza: Peel the paper off the bottom of the bun before you eat it.

PORK DUMPLING – SIU MAI – 燒賣

Sarah: Really good with soy sauce or dipped in chilli sauce.

Carl: A pork meatball, I can eat a hundred of these.

Julie: Good for people who don't like the wrapping of most dim sum dishes. The meat is firm and flavour is mild. A good introduction to the dim sum family.

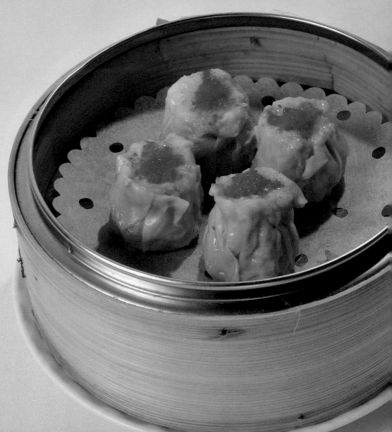

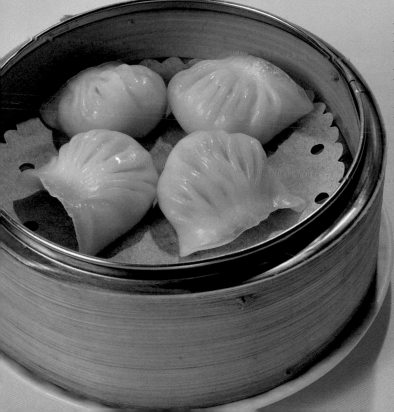

Prawn dumpling – Har gau – 蝦餃

Jennifer: The prawns are nice and firm.

James: Chilli sauce goes well with this one as well but I don't like the slippery, sticky wrapper so I just ate the prawns inside.

Liza: The thinner the skin, the higher the quality of the wrapper.

PORK RIBS IN BLACK BEAN SAUCE – PAI GWAT – 豉汁排骨

Kathy: Too fatty, it's hard to eat around the fat with my chopsticks. There's not enough meat.

Steven: Black bean sauce mixed with the chilli makes a good base for this dish.

Liza: You'd have to spit out the bones. You will notice Chinese people savour the fat as well.

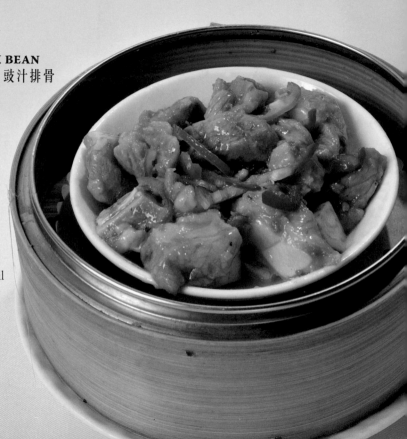

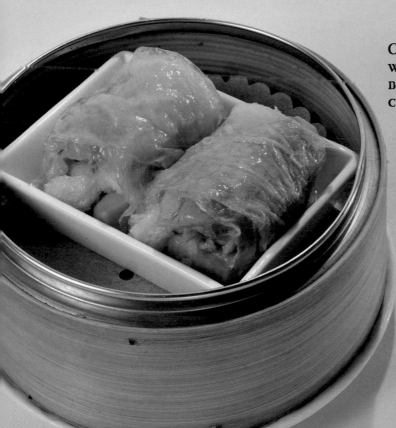

CHICKEN WRAPPED WITH HAM, MUSHROOMS, BAMBOO SHOOTS, CABBAGE – GAI JAT – 雞札

Jennifer: This is a good one. The fillings are quite generous, the tofu skin wrapping is a little chewy. Overall a good savoury dish with meats that I recognize.

James: Do I put the whole thing in my mouth at once?

Liza: You take one bundle and then you eat the filling one piece at a time.

SHANGHAI SOUP DUMPLINGS – SIU LONG BAU – 小籠包

Sarah: There is soup inside the dumpling, so let it cool down a little first otherwise you'll get burned. Dip it in the vinegar sauce then put the whole thing into your mouth at once.

Kathy: How do they get the soup into the dumpling?

Liza: You have to eat this while it's warm, not after it's turned cold. These dumplings are usually filled with pork but sometimes with shellfish as well. You may need to check if you are allergic.

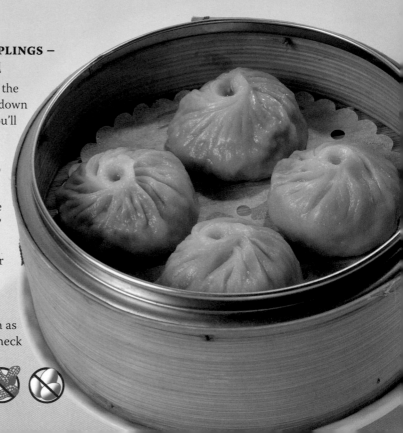

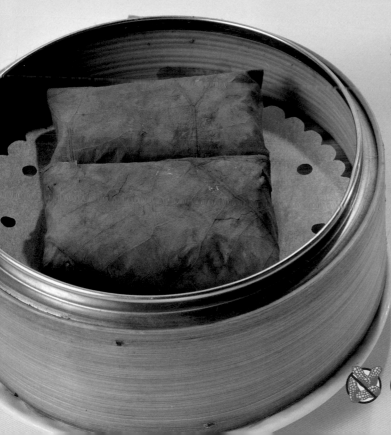

SAVOURY CHICKEN AND STICKY RICE WRAPPED IN LOTUS LEAF – LAW MAI FAN – 糯米雞

Jennifer: Unwrap the lotus leaf and eat the filling. The rice and chicken is so moist.

Carl: You have to like the smell of lotus leaves to enjoy this dish but it doesn't smell 'leafy'.

Julie: The texture is very sticky and mushy. The dried shrimps are a little fishy.

CHICKEN FEET –
FUNG JOWL – 鳳爪

Alice: Where's the meat in the chicken feet?

Carl: I like to try weird foods; the chicken feet are basically a vehicle for the black bean sauce. Yes, the best thing about it is the sauce.

Julie: So many bones to spit out! At least they trimmed the claws.

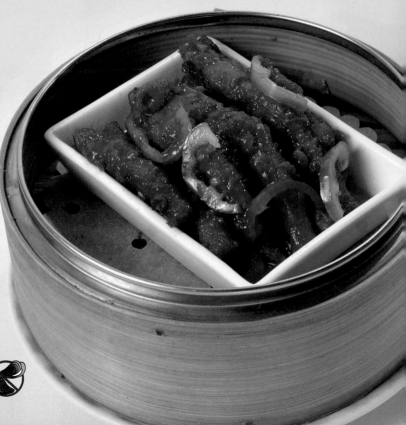

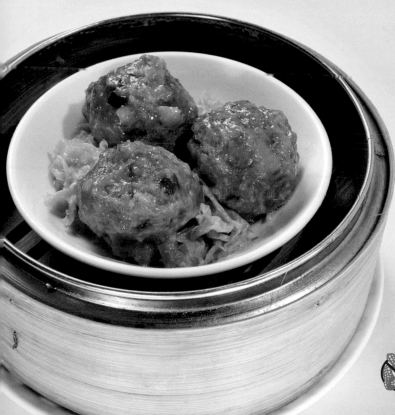

STEAMED BEEF MEATBALLS WITH CILANTRO – AU YUK KAU – 牛肉球

Kathy: Tastes like Italian meat balls without the tomato-based sauce.

Carl: The cilantro is very strong in this dish.

Julie: It's very moist and soft, maybe because it's steamed.

ASSORTED BEEF ORGANS – AU JUP – 牛雜

James: It looks exactly as it sounds, the insides of a cow. No way am I eating that!

Steven: The texture is like warm chewing gum but the sauce is good.

Liza: The pancreas (the dark brown piece) is soft and not mealy. The honeycomb tripe is the best, it's soft, its texture feels like chicken. The omasum tripe, the one with the pieces hanging off, is the chewiest.

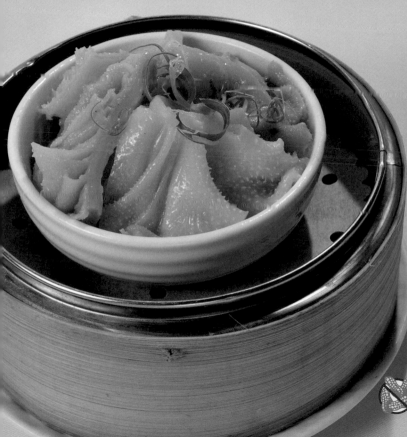

BEEF TRIPE – AU PARK YIP – 牛百葉

Jennifer: It's all honeycomb tripe if you like that sort of thing.

Carl: Garlicky and saucy, it's an acquired taste. Takes some chewing to get it down.

Liza: I love the large pieces of Chinese white radish because they have soaked up all the sauce. The flavour is intense.

CHIU CHOW STEAMED DUMPLINGS – CHIU CHOW FUN GOR – 潮州粉果

James: The peanuts are a nice surprise!

Kathy: The pork and chives and peanuts make a nice blend of flavours and textures.

Steven: It's different from other dumplings because it's not just meat, that's a nice change.

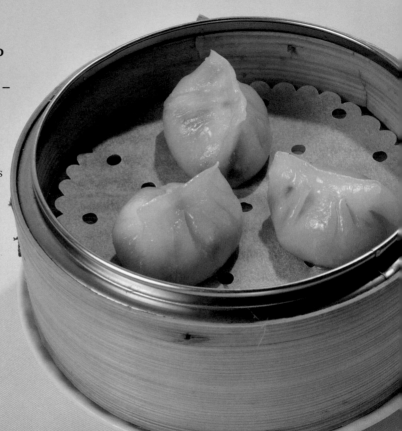

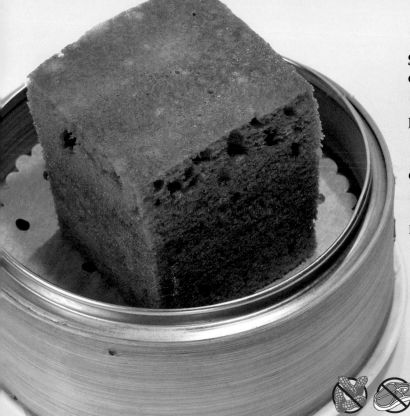

STEAMED SPONGE CAKE – MA LIE GO – 馬拉糕

Jennifer: Healthy cake with no butter, give me more!

Carl: It's very light, it looks like a lot to eat but melts in my mouth.

Liza: It's just brown sugar, flour and eggs, and not too sweet.

STEAMED RICE SHEET ROLLS
WITH SHRIMP – HAR CHEUNG – 蝦腸

Jennifer: The skin is quite slippery to pick up with chopsticks, so you may need a spoon to help you scoop up the pieces.

James: This is similar to 'Har gau', shrimp dumplings, but the noodle is thicker. It's almost like a shrimp wrap.

Liza: You may want to use your chopsticks to cut the long noodle in half to share. Make sure you get some soy sauce, or it can be quite bland.

STEAMED RICE SHEET ROLLS WITH BEEF – AU CHEUNG – 牛腸

Jennifer: The minced beef is very moist. I like to drench it in soy sauce.

Carl: It's so soft that people with dentures can eat this.

Julie: It resembles meat balls wrapped inside soft pasta, but there's no tomato sauce.

STEAMED RICE SHEET ROLLS WITH
BBQ PORK – CHAR SIU CHEUNG – 叉燒腸

Jennifer: The noodle is very slippery. I need to lift
it onto my spoon to eat it.

Carl: It slides down my throat so easily. The BBQ pork gives
this dish a bit more texture.

Sarah: Really nice with the soy sauce. It's a simple dish but
well executed.

STEAMED RICE SHEET ROLLS WITH FRIED DOUGH – JAR LEUNG – 炸兩

Kathy: The fried dough gives this dish a greasier feel but it tastes good. Soft on the outside... a little chewy, like a soft pretzel, on the inside.

Carl: I want to eat the fried dough by itself without the noodle; I bet it would be crispier. Right now it's kind of tough and chewy because of the steaming.

Liza: The trick is to get the dough to stay crispy during steaming. Only the best dim sum chef can achieve that. Then you have to serve it right away. If this dish has been sitting on the trolley for too long, then it's not the best.

PORK AND CHIVE DUMPLING –
GAU CHOI GAU – 韭菜餃

James: This is another one that has a
nice mix of meat and vegetables
so it's a nice textural difference
from the other dumplings.
The Chinese chives are more
intense in flavour than
regular chives, and it tastes
more garlicky.

Alice: It looks like if you threw
it at the window, it would
stick. The flavour is quite salty
and it's a lot of hard work to chew.

Liza: Sometimes there's a variation
with a prawn and chive dumpling
for non-pork eaters.

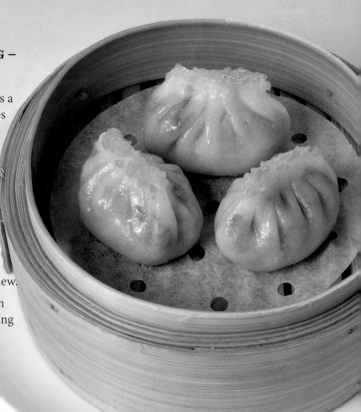

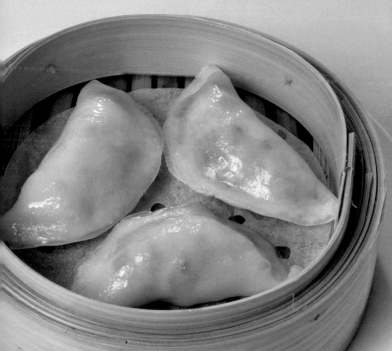

STEAMED VEGETABLE DUMPLING – SO FUN GOR – 蒸素粉果

David: I'm not sure I like this gelatinous wrapper. It's like a jellyfish texture then it's chewy inside.

Carl: A little peppery and spicy.

Liza: The texture of the filling is meat-like but it's not meat.

MINCED PORK, MUSHROOM, BAMBOO SHOOT IN TOFU SKIN WRAP – SIN JOK GUEN – 鮮竹卷

Jennifer: I love this, it's like eating a soggy spring roll. I could eat this all day.

Steven: It's firm, I like the juice inside, it tastes like a meatball.

Julie: Kids like this one too and it's very healthy.

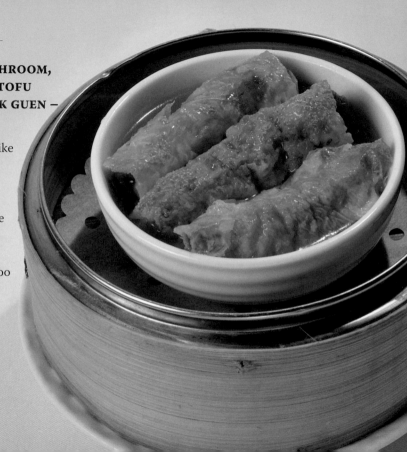

Deep Fried
Pan Fried

CALAMARI WITH SPICY SALT – JAR YAU YU – 炸鱿魚

Sarah: I'm not used to eating squid; some pieces are hard to chew. It's like chewing gum and it looks like seahorses.

David: I love the light crispy coating. It's like chewy cheese strings.

Liza: Some restaurants don't serve the spicy salt with it and then it tends to be bland. It's much better when dipped in the spicy salt or the dark vinegar.

SPRING ROLLS – CHUN GUEN – 春卷

Kathy: My all time favourite! Crispy on the outside and just enough filling to make it a hearty snack.

Carl: Some restaurants will cut them into bite-size pieces for you so you can pick them up with chopsticks.

Liza: They serve Worcester sauce on the side to give the spring rolls a bit of a tang. Some restaurants serve thinner versions which are crispier but don't have as much filling.

FRIED WONTONS – JAR WON TON – 炸雲吞

Jennifer: A combo of potato chips and shrimp. The wrapper is thinner than potato chips only it's even crispier.

David: The sweet and sour sauce makes it.

Alice: Not the healthiest food on the menu but the kids sure love this one.

FRIED EGG-SHAPED DUMPLING – HARM SHUI COK – 咸水角

Jennifer: This savoury dumpling is deep fried but not greasy. The shell is crispy on the outside but soft on the inside, it's a good combination.

Kathy: The savoury pork filling is a nice surprise.

Liza: The wrapping is made from rice flour dough so it's quite light, and the minced pork inside is just juicy enough to make it not too dry.

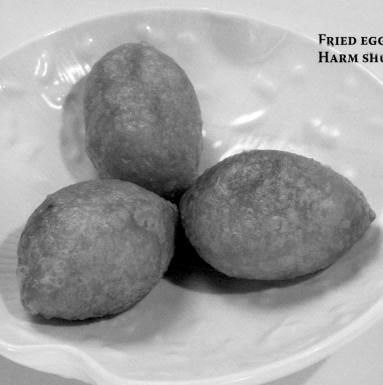

Taro dumplings – Wu gok – 芋角

Jennifer: This one will stay with me for a while.

Carl: The outside is a mashed-potato mixture but when it's in your mouth it gets very mushy.

Julie: Taro is a root vegetable so the texture is very similar to potato. The ground pork is savoury and quite nice.

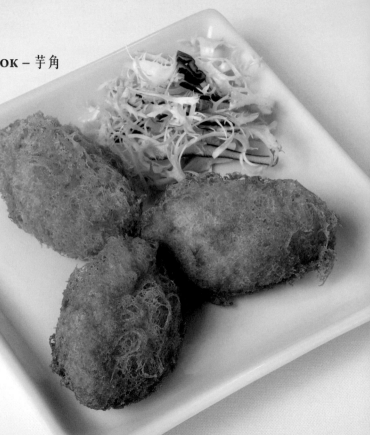

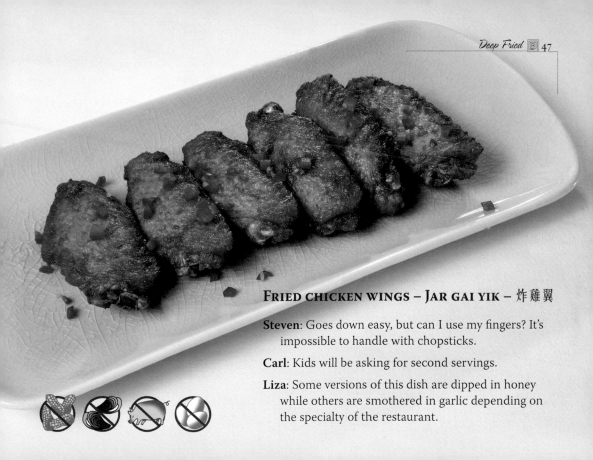

FRIED CHICKEN WINGS – JAR GAI YIK – 炸雞翼

Steven: Goes down easy, but can I use my fingers? It's impossible to handle with chopsticks.

Carl: Kids will be asking for second servings.

Liza: Some versions of this dish are dipped in honey while others are smothered in garlic depending on the specialty of the restaurant.

FRIED EGG PASTRY –
DAN SO – 蛋散

David: Tastes like churros
from Texas. But it's like eating
fried air; it melts in your mouth
as soon as you eat it.

Carl: Extremely sweet, like eating fairy floss (cotton
candy). The corn syrup coating is very sticky. You
can hear your arteries hardening as you eat it.

Julie: The pastry is so light it melts in your mouth.

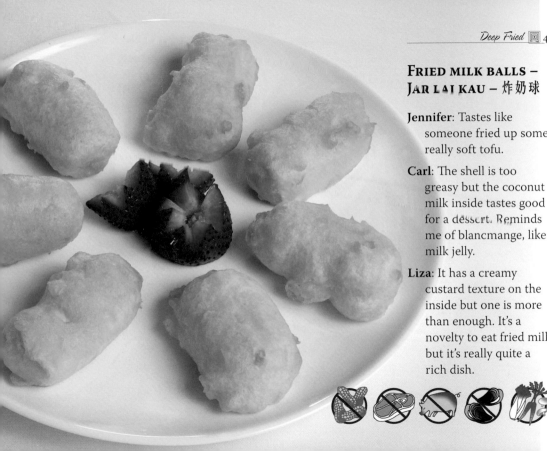

FRIED MILK BALLS – JAR LAI KAU – 炸奶球

Jennifer: Tastes like someone fried up some really soft tofu.

Carl: The shell is too greasy but the coconut milk inside tastes good for a dessert. Reminds me of blancmange, like milk jelly.

Liza: It has a creamy custard texture on the inside but one is more than enough. It's a novelty to eat fried milk but it's really quite a rich dish.

PAN-FRIED RICE SHEET ROLLS WITH DRIED SHRIMP – GIN CHEUNG FAN – 煎腸粉

Steven: You have to eat this hot, otherwise it's like cold rubbery pasta.

David: The skin is crispy and the flavour of the spring onion is nice.

Liza: The sweet sauce is the dark brown one and the sesame sauce is the caramel-coloured one. It's quite bland if you don't dip, but some people like it that way.

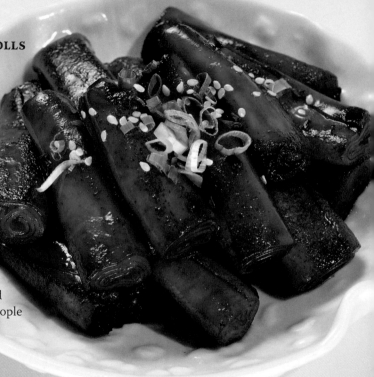

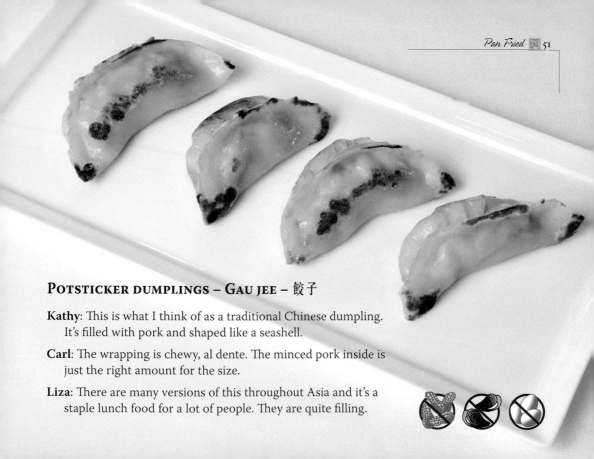

POTSTICKER DUMPLINGS – GAU JEE – 餃子

Kathy: This is what I think of as a traditional Chinese dumpling. It's filled with pork and shaped like a seashell.

Carl: The wrapping is chewy, al dente. The minced pork inside is just the right amount for the size.

Liza: There are many versions of this throughout Asia and it's a staple lunch food for a lot of people. They are quite filling.

PAN-FRIED RADISH PASTE WITH MINCED DRIED SAUSAGE – LAW BUCK GO – 蘿蔔糕

Jennifer: It's essentially a savoury pudding. The Chinese sausage tastes like chorizo.

Carl: It's a little too soft for me, the pan-frying makes the outside a bit crispy but still it's too mushy when it's in my mouth.

Liza: There are some small dried shrimps, mushrooms and Chinese dried sausages inside to make it a bit more tasty.

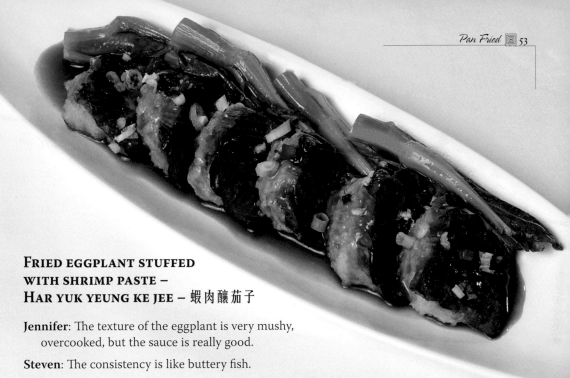

FRIED EGGPLANT STUFFED WITH SHRIMP PASTE – HAR YUK YEUNG KE JEE – 蝦肉釀茄子

Jennifer: The texture of the eggplant is very mushy, overcooked, but the sauce is really good.

Steven: The consistency is like buttery fish.

Julie: The flavour of the sauce is a little bit too heavy for fish. However, if you like eggplant, you will enjoy this dish.

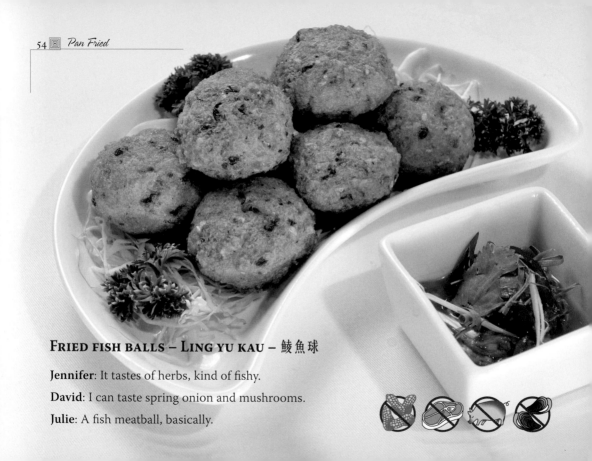

FRIED FISH BALLS – LING YU KAU – 鯪魚球

Jennifer: It tastes of herbs, kind of fishy.

David: I can taste spring onion and mushrooms.

Julie: A fish meatball, basically.

Inside the Dim Sum Kitchen

The hierarchy of a Chinese kitchen is very different from what you might see on the Food Network on TV. There is still plenty of hustle and bustle, and the king of the kitchen is still the master chef or supervisor chef. But the road to being a Chinese master chef is not easy and the respect and prestige that comes with it in a food-revering nation is immense.

This is a male-dominated industry and it is very rare to find women dim sum chefs because it is such a physically-, mentally- and time-demanding job. A reputable master chef can earn between 3,200 and 4,500 USD a month – not bad considering Hong Kong income tax is maxed at 15 percent! It's not uncommon for these teams of chefs to make up to 3,000 baskets of dim sum a day.

Traditionally they would prepare everything from scratch, from making the skins of the dumplings to shelling prawns to steaming baskets, in order to get ready for the breakfast rush. You see, dim sum was originally a breakfast dish. Lack of sufficient refrigeration meant everything had to be prepared on the spot

every single day. Everything was made in the middle of the night and served for breakfast. Leftovers were discarded and never saved for the next day, as chefs believed that refrigeration would alter the texture of the dumpling skins and would ruin their carefully hand-made works of art. Their day would end by noon.

*N*owadays dim sum can be served for breakfast or lunch and diners are less picky. Most of the easy-to-make dishes, like beef balls and BBQ pork buns, can be pre-made elsewhere and shipped to various restaurants by refrigerated trucks for final steaming or frying – although the more delicate dim sums such as shrimp dumplings are still prepared on site. So dim sum chefs can now afford to go to work at 6:00 in the morning instead of at 3:00. You can even find 'siu mai' sold at convenience stores, where easy access means more than quality.

To find the best and the healthiest dim sum, your best bet would be the restaurants in five-star hotels. You will be guaranteed the quality of the ingredients, and as the head chefs of these restaurants are often foreign nationals, they tend to shun MSG and look towards healthier alternatives, more expensive, hard-to-get ingredients and longer preparation times. So if you are allergic to

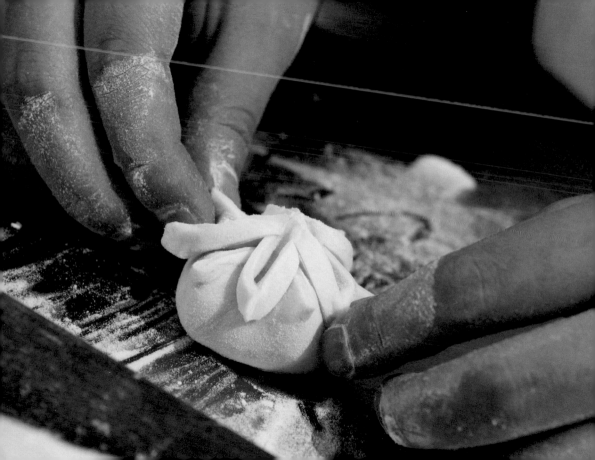

MSG, stick with five-star hotels. Traditionally, smaller restaurants have relied on MSG to flavour dishes in order to save time and money on making supreme stocks. This powder is easy to use, requires no preparation time and is low-cost. That is why 'dai pai dongs' (open roadside eateries) and 'cha chan tengs' (Hong Kong diners) rely so much on MSG.

There are two different styles of dim sum. The Southern style has Cantonese origins. The ingredients are usually seafood-based, as this cuisine was founded near the coast. This kind of dim sum is what you see rolled around on trolleys. The Northern type of dim sum usually has thicker skins, uses a lot of lard, and is served in Shanghainese restaurants.

Baked/roast

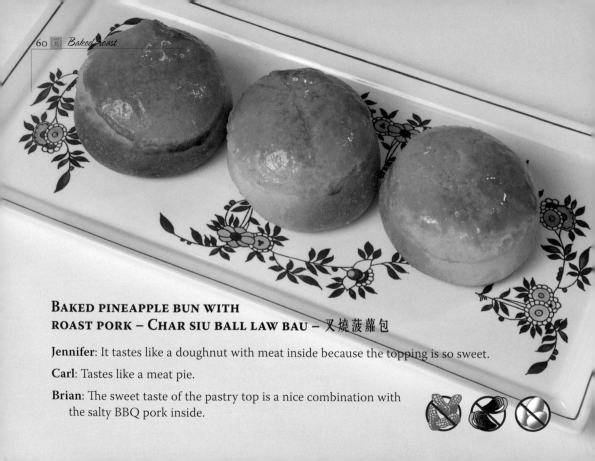

BAKED PINEAPPLE BUN WITH
ROAST PORK – CHAR SIU BALL LAW BAU – 叉燒菠蘿包

Jennifer: It tastes like a doughnut with meat inside because the topping is so sweet.

Carl: Tastes like a meat pie.

Brian: The sweet taste of the pastry top is a nice combination with the salty BBQ pork inside.

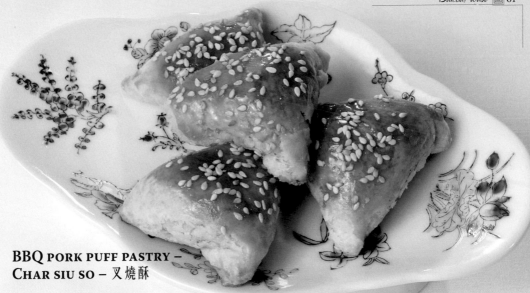

BBQ PORK PUFF PASTRY – CHAR SIU SO – 叉燒酥

Jennifer: The light pastry shell is like a croissant and mixes well with the BBQ pork inside.

Carl: It tastes very much like a sausage roll.

Liza: The topping is slightly sweet because they've put on a honey glaze. I really like the sesame seeds.

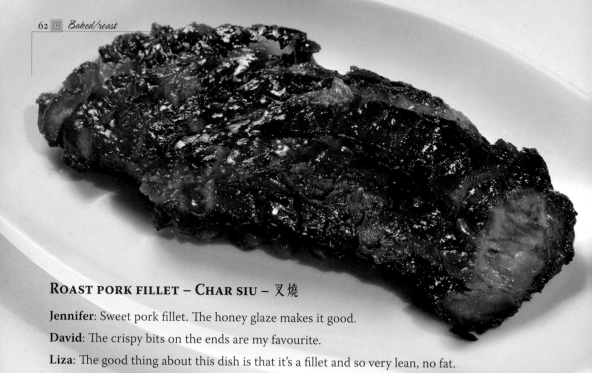

ROAST PORK FILLET – CHAR SIU – 叉燒

Jennifer: Sweet pork fillet. The honey glaze makes it good.

David: The crispy bits on the ends are my favourite.

Liza: The good thing about this dish is that it's a fillet and so very lean, no fat.

Baked/roast 63

ROAST PORK LOIN WITH SKIN –
SIU YUK – 燒肉

Jennifer: I need to eat around the fat. It's salty, not sweet.

Carl: Like regular roast pork but no gravy, and more tender and juicy.

Liza: When this is done perfectly the skin should be crispy. The flesh should be a little salty and tender.

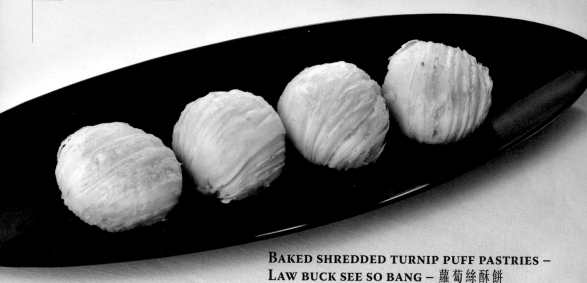

BAKED SHREDDED TURNIP PUFF PASTRIES –
LAW BUCK SEE SO BANG – 蘿蔔絲酥餅

Kathy: I love the outside, it tastes like savoury pastry. Like a pasty.

Brian: Looks like a little croissant and tastes like one on the outside. But the inside tastes like moist shredded potatoes.

Liza: This dish has bits of ham in it to give it more flavour.

BAKED BBQ PORK BUN –
CHAR SIU CHAN BAU – 叉燒餐包

Jennifer: It's a sweeter version of the traditional white BBQ pork bun.

Carl: The bread is sweet and soft with a light egg glaze on top.

Liza: This bun is considered a westernized version of the steamed white bun. The filling is the same. These are best eaten warm.

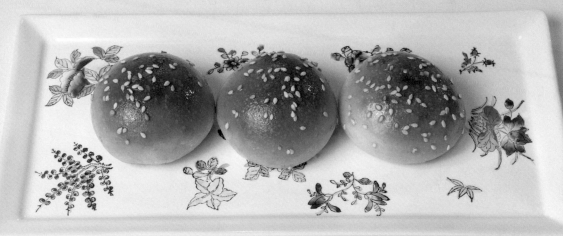

The Dim Sum Master Chef

An interview with Jacky Lau, supervisor of dim sum at Super Star Seafood Restaurant, Causeway Bay

*D*im sum supervisor chef Jacky Lau has had the right side of his body burnt to a crisp, but he is more determined than ever to perfect his craft and make new and interesting dim sum dishes for his customers.

Lau fell into the profession by chance. After high school he failed to get the grades to train for his dream job, an interior designer. Not wanting to worry his parents with an extra mouth to feed, he decided to take a temporary job as a stir-fry chef at a local restaurant. After two rigorous years tossing the heavy iron wok, his wrists became so weak that he had to give up the profession for good. His fellow chefs convinced him that working with delicate dim sum dishes was far easier on his wrists.

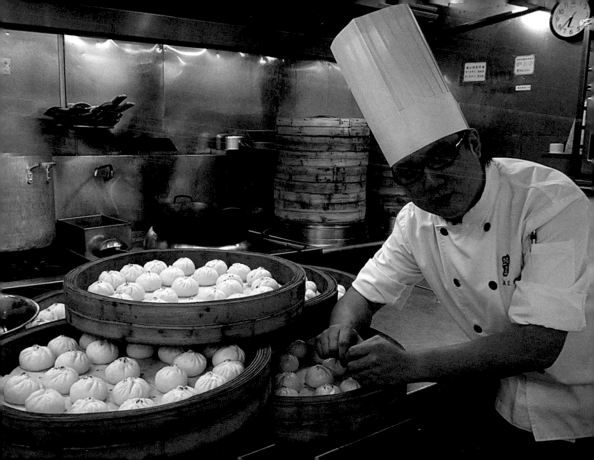

"I had to start at the bottom of the ladder, from trainee level. Traditionally it takes around 15 years to become a supervisor chef but I got a lot of breaks and I was promoted through the ten ranks quickly," explains Lau. "I had to learn to make over 200 different dishes throughout my dim sum training." On any given day there are at least ten chefs in the kitchen, chopping fillings, wrapping, kneading dough, steaming and frying. These ten chefs prepare over 2,300 dishes a day at Lau's restaurant.

"Each of us put in 12-hour days in the kitchen. It's physically very hard work but it's great when customers ask to see and thank us if they have had a nice meal. There are some Japanese clients who come in with their guidebooks and ask to take photos with us because their book had recommended our restaurant."

You would never know it, but the jovial Lau suffered a serious kitchen injury, burning the whole right side of his body, his face, hair and arm. After resting for a month in hospital, he had to take a further two months off for recovery. But the ever-smiling chef jumped right back into work after that incident, asking his mother to draw in some eyebrows so he wouldn't look so strange.

The scars are gone now, physically and psychologically. His proudest moments are competing in dim sum cooking competitions such as the annual Hong Kong 'Best of the Best' held at the Chinese Cuisine Training Institute, and representing his restaurant in cooking demonstrations overseas in places such as France, Japan and Taiwan.

Lau's profession stays with him 24/7 – on his days off, he samples dim sum at other restaurants to try to work out his competitors' secret recipes. Being at the top of the dim sum pyramid, he is free to experiment and create new flavours and textures, a luxury denied to the lower ranks.

What is the most difficult dish to make? Lau doesn't hesitate in his answer. "The most difficult dishes are the most common and popular ones, like har gau (shrimp dumpling) and siu mai (pork dumpling). Because we make so many every day, our minds go into auto-pilot, so it would be easy to make mistakes." He adds, "Food always tastes best when your heart goes into the cooking. That's why my mother's cooking tastes the best to me."

Vegetables

STEAMED GREEN VEGETABLES WITH OYSTER SAUCE – HO YAU YAU CHOI 蠔油油菜

Brian: The most basic veggies steamed to lock in the vitamins. Nice crunch, not overcooked.

James: You can really taste the sweetness of the vegetables. The oyster sauce just gives it a salty flavour and doesn't taste like oysters.

David: It's good to have some vegetables in a dim sum meal. This plain dish doesn't overwhelm the flavours of the other dishes.

FRIED WATER SPINACH WITH YELLOW BEAN PASTE – FU YU TONG CHOI – 腐乳通菜

Kathy: Water spinach is not as stalky as the other Chinese vegetables. It's very thin and soft and doesn't require much chewing.

Carl: The yellow bean paste is very salty so make sure you mix it well into the vegetables and don't get it all at once. It's a bit of an acquired taste but good.

Liza: Most non-Chinese find that this is their favourite vegetable dish.

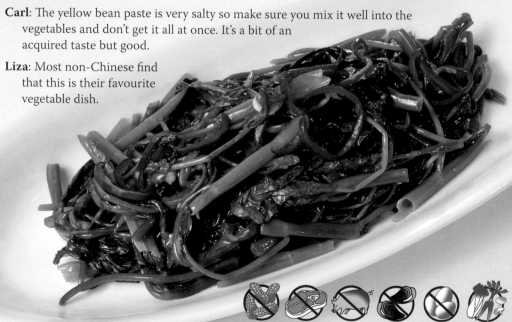

STIR-FRIED CHOI SUM – CHOW CHOI SUM – 炒菜心

David: Crispy vegetables, I really feel the ginger and garlic flavour. Very sweet compared to the other Chinese vegetables.

Sarah: It goes very well with steamed rice. The stalks are easy to chew and the leaves soak up the flavours of the ginger and garlic.

Liza: A Cantonese staple. Most locals choose the stalks with the tiny yellow flowers because it's the sweetest part of the plant. A good dish for children.

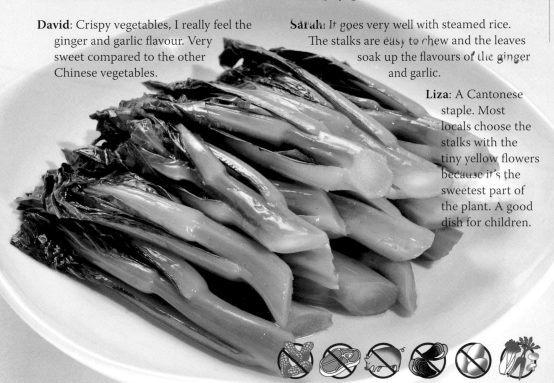

STIR-FRIED BOK CHOY (CHINESE CABBAGE) – CHOW BOK CHOY – 炒白菜

Kathy: Tastes a little like cabbage with a slight bitter flavour.

Brian: The stem is softer than Chinese broccoli but has a wonderful crunchy texture.

Liza: Another very popular vegetable with the locals. Stir-fried very quickly in a hot wok keeping the essential vitamins of the plant but bringing out the flavours of the garlic.

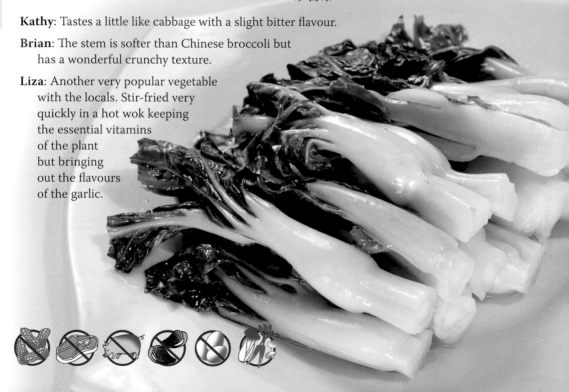

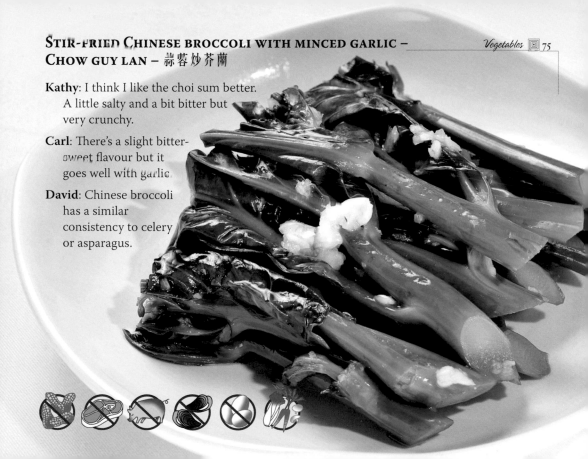

STIR-FRIED CHINESE BROCCOLI WITH MINCED GARLIC – CHOW GUY LAN – 蒜蓉炒芥蘭

Kathy: I think I like the choi sum better. A little salty and a bit bitter but very crunchy.

Carl: There's a slight bitter-sweet flavour but it goes well with garlic.

David: Chinese broccoli has a similar consistency to celery or asparagus.

TOFU HOT POT – DAU FU BO – 荳腐煲

Alice: I love the hot pot. It keeps the food warm.

Carl: The food soaks up the flavour of the gravy; the tofu is so soft but doesn't have that bean smell. This is the best way to eat tofu.

Liza: This is a very popular winter dish as it is a Cantonese comfort food. If you don't want meat or shellfish, then you need to let your waiter know. Check the Cantonese phrases section of the book.

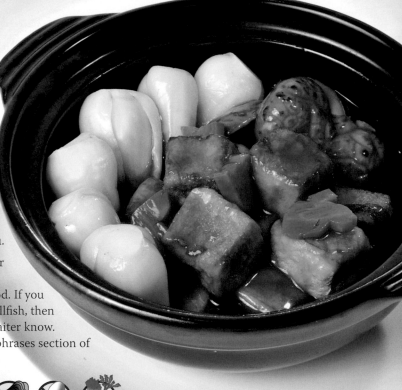

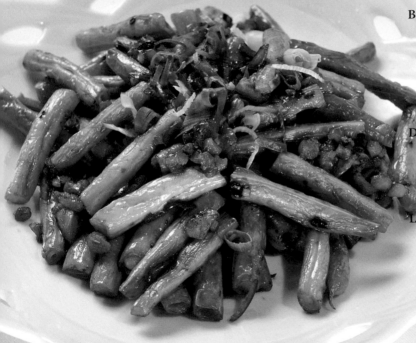

Brian: I am familiar with regular green beans but these Chinese beans are more tender. These are good because they are not as chewy as the leafy vegetables.

David: The minced pork, beans and garlic combination is great. Goes down easy with steamed rice.

Liza: Just the right mixture of beans to meat. Another very popular dish with people who are new to Chinese vegetables.

Top ten dim sum dishes for kids

In the best of circumstances, kids are fussy about trying new foods. Here are ten tried-and-true dishes that will tempt the most pernickety of eaters.

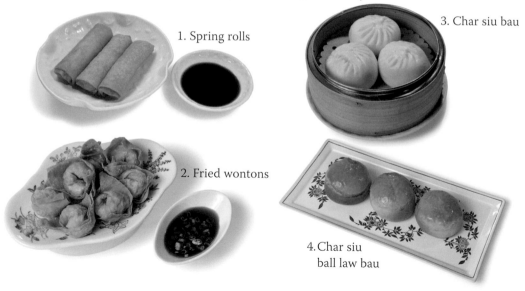

1. Spring rolls

3. Char siu bau

2. Fried wontons

4. Char siu ball law bau

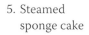

5. Steamed sponge cake

8. Pan-fried noodles

6. Chicken wings

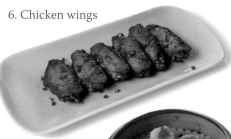

9. Egg tarts

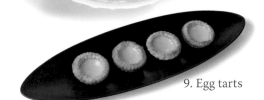

7. Siu mai

10. Shrimp dumplings

Rice Noodles

Fried rice – Yeung jau chow fan – 揚州炒飯

Jennifer: Classic fried rice, a bit of shrimp, a bit of BBQ pork and some veggies.

David: This is delicious. Fragrant rice with the right balance of meat and vegetables.

Liza: Good fried rice shouldn't be too greasy, nor should the rice clump together.

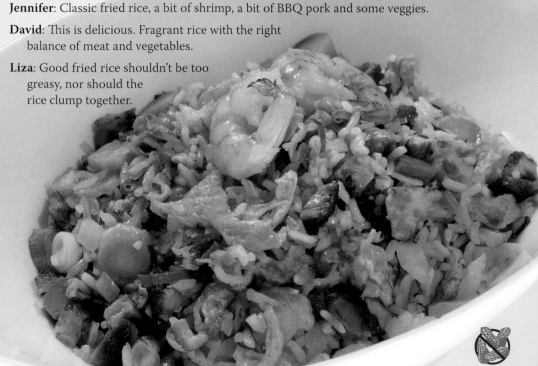

FRIED RICE WITH SEAFOOD WHITE SAUCE AND TOMATO SAUCE WITH PORK (LOVEBIRD FRIED RICE) – YIN YEUNG CHOW FAN – 鴛鴦炒飯

Alice: This is new for me. You can mix the two sauces together or eat each side separately.

James: Two different sauces on the one dish. But the bases are much lighter, not as heavy as Italian pasta sauce. I like the big prawns in the white sauce.

Julie: The two sauces give a new twist to the traditional fried rice dish. Moist like a risotto but with huge chunks of pork and seafood.

FUKIEN FRIED RICE WITH GRAVY –
FOOK KIEN CHOW FAN – 福建炒飯

Brian: This is fried rice with gravy with chunks of chicken, shrimp, mushroom and kale. More filling than regular dry fried rice.

Alice: Nice and moist, the brown gravy is savoury with a mild, pleasant taste.

Liza: This is a meal in itself. You would definitely order this to share around the table.

Vegetable fried rice – So chow fan –
如意素炒飯 (不要肉或海鮮)

David: With so much meat in dim sum, sometimes I just want some vegetable fried rice. It's not as heavy as regular fried rice.

Carl: This is a good alternative to plain white rice. It's just a bit more interesting without being too filling with my dim sum meal.

Liza: This is not a traditional dish served in Chinese restaurants. So please show the Chinese characters to a waiter to make sure you don't get meat in this fried rice!

SHREDDED PORK WITH FRIED NOODLES –
YUK SEE CHOW MIEN – 肉絲炒麵

Jennifer: This is so good because the gravy and the noodles make a good combination. It's different from other fried noodles because the noodles are ultra-thin egg noodles.

Brian: I like the bean sprouts; they give a bit of crispness. The best fried noodles I have had.

Liza: The noodles should be crispy if it's done well. Mix the yellow mustard into the noodles and eat it all up.

Wonton noodle soup – Won Ton Mien – 雲吞麵

Sarah: The wontons are filled with large pieces of prawn so it's quite hearty.

Carl: The broth is a light beef broth, the fresh spring onions add a nice flavour.

Liza: The secret is in the broth. If the broth is made with good ingredients then it tastes great, if not then it just tastes salty. Also, the noodles should be al dente, just a bit firm to the bite.

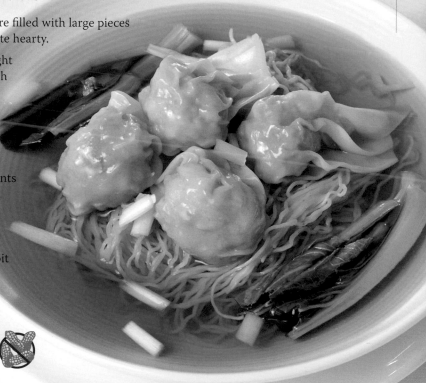

FRIED FLAT NOODLE WITH BEEF –
GONE CHOW AU HALL – 乾炒牛河

Jennifer: This flat white noodle is starchier than egg noodles; it's more like a fried pasta dish.

Kathy: Very flavourful, beefy, the noodles have a mild soy sauce taste. A very satisfying dish, good for sharing among friends.

Liza: This dish is cooked at a very high temperature and the soy sauce is caramelized on the noodles. The right amount of oil makes sure the noodles don't clump together but not too much that it all becomes greasy.

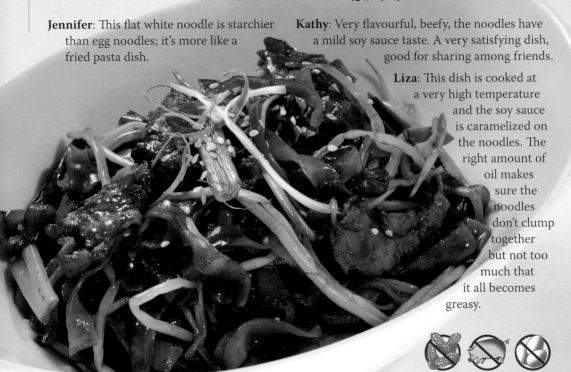

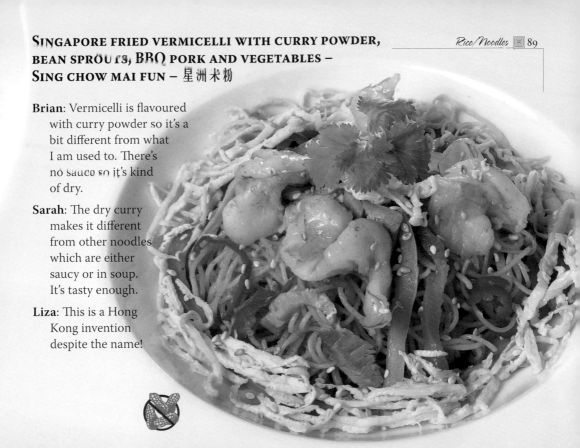

SINGAPORE FRIED VERMICELLI WITH CURRY POWDER, BEAN SPROUTS, BBQ PORK AND VEGETABLES – SING CHOW MAI FUN – 星洲米粉

Brian: Vermicelli is flavoured with curry powder so it's a bit different from what I am used to. There's no sauce so it's kind of dry.

Sarah: The dry curry makes it different from other noodles which are either saucy or in soup. It's tasty enough.

Liza: This is a Hong Kong invention despite the name!

Sweets

CUSTARD TARTS – DAN TART – 蛋撻

Jennifer: Tastes like a mini-pie. The pastry part is a sweet pie pastry.

Carl: The pastry is delicious but I can tell that the custard might be too sweet for some people.

Liza: One of my favourite desserts. There's nothing like freshly made custard tarts when they're still warm.

MANGO PUDDING – MONG GOR BO DEAN – 芒果布甸

Alice: Yum, yum! They make it with fresh mango pieces.

Steven: A nice sweet dessert after a big meal but it's not too filling or too sweet.

Liza: Sometimes this dessert can come with little pearls of sago. Either way, everyone loves this dish, even kids.

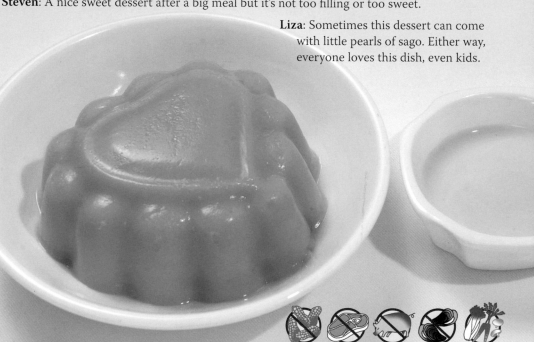

Sesame roll – Jee ma guen – 芝麻卷

David: I can't get used to the colour. It just tastes like a sweet cold piece of gelatine.

Carl: It's a springy texture, very jelly-like.

Liza: This one used to be very popular but it's hard to find now. It's worth a try just once.

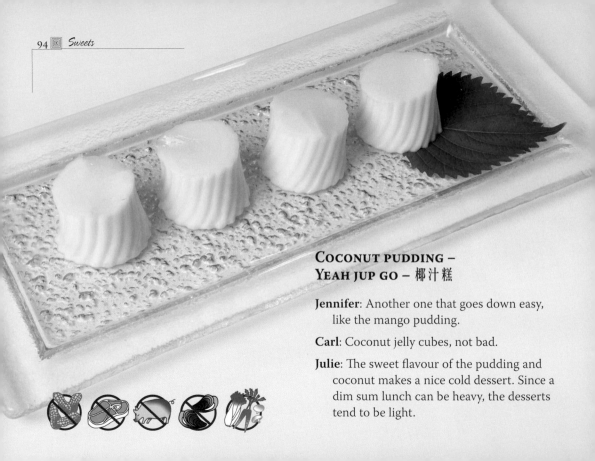

COCONUT PUDDING –
YEAH JUP GO – 椰汁糕

Jennifer: Another one that goes down easy, like the mango pudding.

Carl: Coconut jelly cubes, not bad.

Julie: The sweet flavour of the pudding and coconut makes a nice cold dessert. Since a dim sum lunch can be heavy, the desserts tend to be light.

FRIED SESAME BALLS WITH LOTUS SEED PASTE FILLING – LEEN YUNG GIN DUI – 蓮蓉煎堆

Jennifer: It's delicious; the balls are crispy on the outside with delicious sesame seeds.

Carl: The lotus seed paste filling is a little too sweet. I just ate the shell.

Kathy: Tastes a little like a crispy doughnut with the glaze on the inside as opposed to the outside.

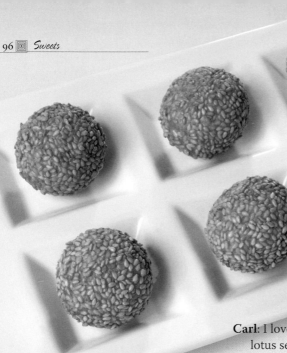

**FRIED SESAME
BALLS WITH RED
BEAN PASTE FILLING –
HOONG DAU GIN DUI –
紅豆煎堆**

Jennifer: You have to like red bean
paste to enjoy this dessert! The
filling has a slight grainy texture, as
you would expect from mashed-up
baked beans, but sweet.

Carl: I love it, the red bean paste is better than the
lotus seed filling. Less sickly sweet.

Liza: Sometimes this dish comes without
any filling so it's just a big empty ball
of chewy dough with sesame seeds.
That one is quite good as well.

BEAN CURD CUSTARD IN GINGER SYRUP – DAU FU FA – 荳腐花

James: Creamy texture, it feels like I'm eating ice-cream.

Carl: I am not a tofu fan but this dish doesn't taste like tofu, it tastes like ginger.

Liza: You can find small vendors around Hong Kong selling this for a few dollars. Sometimes it's served with orange crystals on top. Those are sugar crystals so mix them into your syrup.

Simple Phrases in Cantonese

I'd like to order...and...

Oo seung yiu...tung maai...

我想要……同埋……

Do you have an English menu?

Yau mo ying man chaan pai a?

有冇英文餐牌呀?

Do you have any recommendations?

Yau mat ye ho gai sui a?

有乜好介紹呀?

What are they eating?

Sik gan mat ye a?

佢地食緊乜野呀?

Delicious!

Ho sik a!

好食呀!

Chili sauce, please.

Lat jill john, m goi.

辣椒醬, 吾該。

I cannot eat...

Oo m sik dak...

我吾食得...

Does this have...?

Yau mo...

有冇...

pork	**chu yuk**	豬肉
meat	**yuk**	肉
eggs	**dan**	蛋
peanuts	**far sung**	花生
seafood	**hoi sin**	海鮮
prawns	**haa, haa mai**	蝦, 蝦米
MSG	**mei jing**	味精
salt	**yim**	鹽
wheat	**muk**	麥

Does this have peanut oil?

Yau mo far sung yau ga?

有冇花生油?

White rice, please.

Bak fan, m goi.

吾該比碗白飯。

I am a vegetarian.

Oo sik jai ga.

我食齋架

May I have a knife and fork?

Oo yiu dou cha, m goi.

吾該比份刀叉我

Check/Bill, please.

M goi, maai dan.

吾該埋單

Quick Reference Guide

 PEANUT ALLERGY SAFE

BBQ pork bun

Pork dumpling

Prawn dumpling

Pork ribs in black bean sauce

Chicken wrap with ham, mushrooms,
 bamboo shoots, cabbage

Shanghai soup dumplings

Savoury chicken and sticky rice wrapped in
 lotus leaf

Chicken feet

Steamed beef meatballs with cilantro

Assorted beef organs

Beef tripe

Steamed sponge cake

Steamed rice sheet rolls with shrimp

Steamed rice sheet rolls with beef

Steamed rice sheet rolls with BBQ pork

Steamed rice sheet rolls with fried dough

Pork and chive dumpling

Steamed vegetable dumpling

Minced pork, mushroom, bamboo shoot in
 tofu skin wrap

Calamari with spicy salt

Spring rolls

Fried wontons

Fried egg-shape dumpling

Taro dumplings

Fried chicken wings

Fried egg pastry

Fried milk balls

Pan fried rice sheet rolls with dried shrimp

Potsticker dumplings

Pan fried radish paste with minced dried
 sausage

Fried eggplant stuffed with shrimp paste

Fried fish balls

Custard tarts

Mango pudding

Sesame roll

Coconut pudding

Fried sesame balls with lotus seed paste
 filling

Fried sesame balls with red bean paste
 filling

Bean curd custard in ginger syrup

Baked pineapple bun with roast pork

BBQ pork puff pastry

Roast pork fillet

Roast pork loin with skin

Baked shredded turnip puff pastries

Baked BBQ pork bun

Fried rice

Fried rice with seafood white sauce and
 tomato sauce with pork

Fukien fried rice with gravy

Vegetable fried rice

Shredded pork with fried noodles

Wonton noodle soup

Fried flat noodle with beef

Singapore fried vermicelli with curry
 powder, bean sprouts, BBQ pork and
 vegetables

Steamed green veggies w/oyster sauce

Fried water spinach with yellow bean paste

Stir-fried choi sum

Stir-fried bok choy

Stir-fried Chinese broccoli with minced garlic

Tofu hot pot

Stir fried garlic green beans with pork

 DISHES WITH NO PORK

Prawn dumpling

Chicken feet

Steamed beef balls with cilantro

Assorted beef organs

Beef tripe

Steamed sponge cake

Steamed rice sheet rolls with shrimp

Steamed rice sheet rolls with beef

Steamed rice sheet rolls with fried dough

Steamed vegetable dumpling

Calamari with spicy salt

Fried wontons

Fried chicken wings

Fried egg pastry

Fried milk balls

Pan fried rice sheet rolls with dried shrimp

Fried eggplant stuffed with shrimp paste

Fried fish balls

Custard tarts

Mango pudding

Sesame roll

Coconut pudding

Fried sesame balls with lotus seed paste filling

Fried sesame balls with red bean paste filling

Bean curd custard in ginger syrup

Vegetable fried rice

Wonton noodle soup

Fried flat noodle with beef

Steamed green veggies w/oyster sauce

Fried water spinach with yellow bean paste

Stir-fried choi sum

Stir-fried bok choy

Stir-fried Chinese broccoli with minced garlic

Tofu hot pot

 VEGETARIAN DISHES

Steamed sponge cake

Steamed rice sheet rolls with fried dough

Steamed vegetable dumpling

Fried egg pastry

Fried milk balls

Custard tarts

Mango pudding

Sesame roll

Coconut pudding

Fried sesame balls with lotus seed paste filling

Fried sesame balls with red bean paste filling

Bean curd custard in ginger syrup

Vegetable fried rice

Steamed green veggies w/oyster sauce

Fried water spinach with yellow bean paste

Stir-fried choi sum

Stir-fried bok choy

Stir-fried Chinese broccoli with minced garlic

Tofu hot pot

 DISHES WITH NO EGGS

BBQ pork bun

Prawn dumpling

Pork ribs in black bean sauce

Chicken wrap with ham, mushrooms, bamboo shoots, cabbage

Shanghai soup dumplings

Savoury chicken and sticky rice wrapped in lotus leaf

Chicken feet

Steamed beef meatballs with cilantro

Assorted beef organs

Beef tripe

Chiu Chow steamed dumplings

Steamed rice sheet rolls with shrimp

Steamed rice sheet rolls with beef

Steamed rice sheet rolls with BBQ pork

Steamed rice sheet rolls with fried dough

Pork and chive dumpling

Steamed vegetable dumpling

Minced pork, mushroom, bamboo shoot in tofu skin wrap

Fried wontons

Fried egg-shape dumpling

Taro dumplings

Fried chicken wings

Pan fried rice sheet rolls with dried shrimp

Potsticker dumplings

Fried eggplant stuffed with shrimp paste

Fried sesame balls with lotus seed paste filling

Fried sesame balls with red bean paste filling

Bean curd custard in ginger syrup

Baked pineapple bun with roast pork

Roast pork fillet

Roast pork loin with skin

Fried flat noodle with beef

Steamed green veggies w/oyster sauce

Fried water spinach with yellow bean paste

Stir-fried choi sum

Stir-fried bok choy

Stir-fried Chinese broccoli with minced garlic

Tofu hot pot

Stir fried garlic green beans with pork

 DISHES WITH NO SHELLFISH

BBQ pork bun

Pork dumpling

Pork ribs in black bean sauce

Chicken wrap with ham, mushrooms, bamboo shoots, cabbage

Chicken feet

Steamed beef meatballs with cilantro

Assorted beef organs

Beef tripe

Chiu Chow steamed dumplings

Steamed sponge cake

Steamed rice sheet rolls with beef

Steamed rice sheet rolls with BBQ pork

Steamed rice sheet rolls with fried dough

Steamed vegetable dumpling

Minced pork, mushroom, bamboo shoot in tofu skin wrap

Calamari with spicy salt

Spring rolls

Fried egg-shape dumpling

Fried chicken wings

Fried egg pastry

Fried milk balls

Potsticker dumplings

Fried fish balls

Custard tarts

Mango pudding

Sesame roll

Coconut pudding

Fried sesame balls with lotus seed paste
 filling

Fried sesame balls with red bean paste
 filling

Bean curd custard in ginger syrup

Baked pineapple bun with roast pork

BBQ pork puff pastry

Roast pork fillet

Roast pork loin with skin

Baked shredded turnip puff pastries

Baked BBQ pork bun

Vegetable fried rice

Shredded pork with fried noodles

Fried water spinach with yellow bean paste

Stir-fried choi sum

Stir-fried bok choy

Stir-fried Chinese broccoli with minced
 garlic

Tofu hot pot

Stir fried garlic green beans with pork

 DISHES WITH NO MEAT

Steamed sponge cake

Steamed rice sheet rolls with shrimp

Steamed rice sheet rolls with fried dough

Steamed vegetable dumpling

Calamari with spicy salt

Fried egg pastry

Fried milk balls

Pan fried rice sheet rolls with dried shrimp

Fried eggplant stuffed with shrimp paste

Fried fish balls

Custard tarts

Mango pudding

Sesame roll

Coconut pudding

Fried sesame balls with lotus seed paste filling

Fried sesame balls with red bean paste filling

Bean curd custard in ginger syrup

Vegetable fried rice

Steamed green veggies w/oyster sauce

Fried water spinach with yellow bean paste

Stir-fried choi sum

Stir-fried bok choy

Stir-fried Chinese broccoli with minced garlic

Tofu hot pot

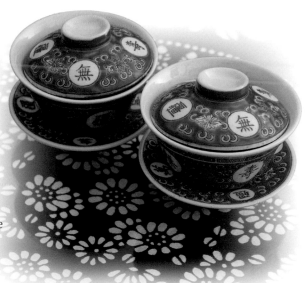

About the author

Liza Chu is a Hong Kong native who began working in her family's Chinese restaurant from the age of 13. After studying in Australia, she spent time living in Japan and the United States. She now lives in Hong Kong where she teaches Cantonese and local culture to American expats. Her regular dim sum excursions with her students prompted the creation of this visual guidebook to Chinese cuisine.

Acknowledgements

I would like to thank my parents, Alex and Connie, who inspired me to try something new; my BFF, Julie Cheney, who believes I can achieve anything; my brother Tony, for his love of all things Chinese; my Cantonese language students who inspired this book; Maurice Kong, Director of Food and Beverage at the Hong Kong Convention and Exhibition Centre; Susan Wallace for introducing me to Mr Kong; Henry Yeung of Sunsing Tea; Erica Cheng at Super Star Seafood Restaurants for supplying us with beautiful dishes to photograph; the Golden Bauhinia Cantonese Restaurant for supplying even more delicious dim sum; Pamela Barton for her idea of a dim sum chart with photos; and Martina Ing, Katrina Shute, Lara Dickinson, Kaylee Smith and their families for going out to yum cha with me and offering invaluable observations and comments.